LIVES
INSPIRED

PORTRAITS OF BREAST CANCER SURVIVORS

PRVCY
PREMIUM

PRVCYPREMIUM.COM

LIVES
INSPIRED

PORTRAITS OF BREAST CANCER SURVIVORS

PRVCY
PREMIUM

PRVCYPREMIUM.COM

PREFACE

by Carolyn Jones, CEO and Founder of PRVCY Premium Denim and PrivacyWear

When someone finds out that they have breast
cancer, what generally happens is they're afraid to
talk about it, or they're afraid to follow up
with their doctor to talk about the options. They feel
fear, naturally and some women go through
this entire experience without having anyone to
talk to, *fearful and alone.*

Which is why we have to talk about it,
people should know it's okay to tell their story.
This book is intended to start that
dialogue by sharing with you the stories of what
the women in these pages
have experienced and accomplished.

FOREWORD

by Carolyn Jones, CEO and Founder of PRVCY Premium Denim and PrivacyWear

SOME OF THESE WOMEN ARE JUST LIKE YOU — AND SOME ARE NOT. The women here all tell of their experiences and challenges quite differently. Some women were angry, some were in shock, some were happy that they had someone to talk to. Most were scared. Some people had the support of loved ones, and some were abandoned in their moment of need. But all of them managed to pull through setbacks, remissions, and hardships. Everyone experiences this in such a different way.

As I read these stories, I could not help but feel encouragement from understanding what people are capable of in the most trying of circumstances. There is beauty in this experience, and it is a rare sort of beauty that is difficult to achieve; one needs to be open, to be willing to engage and to talk about it. Once we start talking about it, we become more educated, more encouraged to be more supportive, and creating that support circle that is so very, very important.

I lost my own mother, Jean James, to breast cancer in 2000. In the hospital, before she passed, she looked at me and said "Do something that you're passionate about and find a way to give back." The result of that conversation was PrivacyWear, which I formed in 2002 in order to bring breast cancer awareness to the fashion marketplace. I was troubled by the immodesty of my mother's hospital gown, and named the company in tribute to the wearer's dignity and respect. We made it our mission to donate a portion of our proceeds towards funding breast cancer education, prevention, and research. We also provide free mammography screening for underprivileged women, and this book is an important next step in our drive to spread awareness.

This book was something that I have wanted to do for a very long time, but have held off on doing because I was occupied with managing the denim brand PRVCY and PrivacyWear. Now I realize that the stories in this book are more important than ever, and that it can't wait.

Statistics show that every 12 minutes a woman in America will die from complications associated with breast cancer. It used to be that women who attended breast cancer events were older, but now the demographic is expanding to be as young as my daughter who is in high school. At our events we're not only seeing an older group of women, but women as young as 17, and a number of women in their 20s.

We need to reach all of these women, hear their stories, and share with them the stories of others who have gone through what they are about to go through. We need to encourage them, show them hope, and give them the gift of the stories we have to share. No one should go through this alone. Our corporate mission is to find a cure for breast cancer, and this book's mission is to share stories, give hope, and spread awareness as the cure is being sought. You are about to read some unforgettable life experiences from breast cancer survivors; when you are done, please be sure to share these stories with someone else.

"FAITH" that we can reach and teach the masses about early detection for breast cancer. Early detection gives us the best chances to successfully fight breast cancer.

- - - - - - - - -

"LOVE" for what we do and we are totally devoted to creating the perfect denim for all shapes and sizes. Our goal is to provide our friends the best fit when it comes to our denim. We will pour all of our love into every style, everyday.

- - - - - - - - -

"HOPE" that a cure for breast cancer is on the way. We will continue to do all that we can to provide information concerning treatment to those that need it. We will also continue our efforts in providing free mammograms to thousands of women across the country.

- - - - - - - - -

THE LIFELINE DESIGN

The lifeline design is inspired by the leap of faith Carolyn Jones, CEO and Founder, experienced during the last days of her mother, Mrs. Jean James life. Mrs. James, who battled with breast cancer, gave her daughter the inspiration to leave her corporate occupation and embark on a journey to find what would give her true happiness. In homage to her mother, Carolyn Jones created the name PRVCY (pronounced Privacy) as her brand from a conversation she had with her mother wanting more privacy from her hospital gown.

The lifeline design tells the story of complacency in Carolyn's professional life to the tragedy of losing her mother to breast cancer, only to triumph through leaning on the words of her mother to find a career with passion.

The company has funded and provided free mammograms to women across the United States and will continue this program as one of the company's core initiatives. The company has also committed to give back up to ten percent of ALL sales proceeds towards breast cancer awareness and free mammogram programs. The company has donated several hundred thousand dollars to breast cancer related programs since 2002.

THE STORIES

THE WOMEN IN THIS BOOK ARE NOT CELEBRITIES, BUT THEY ARE
FAR FROM ORDINARY.

THIS BOOK IS DEDICATED TO THEM.

NANCY SUE BAYRUNS-SKLENCAR

Law Firm Manager by Day, Dance Teacher by Night, 40 Years Old

"Do not go through this alone. If you allow yourself to feel deserving of help and attention and love and hope, there are a ton of people out there who will give you these things. Just reach out for it and it's yours."

DIAGNOSED

November 3, 2005
Stage IIA infiltrating ductal carcinoma,
right breast

TREATMENT

Right breast mastectomy with skin expander
6 rounds of TAC chemotherapy
33 consecutive weekdays of radiation
Bilateral salpingo-oophorectomy
Prophylactic left breast mastectomy
with expander

FAMILY HISTORY

2 paternal aunts

BREAST CANCER GENE

Yes

RESOURCES

Breastcancer.org
Cooper University Hospital
Design-her Gals
FORCE: Facing Our Risk of Cancer Empowered
National Breast Cancer Coalition
Susan G. Komen for the Cure
Young Survival Coalition

GRETA M. CERPA

Executive Assistant, 30

"I'm not the same person anymore, but the person
I am now is beautiful and the connection I feel now is amazing.
It's full of life and that's how it should always be."

DIAGNOSED
May 19, 2006
Stage IIB ductal carcinoma in situ,
right breast

TREATMENT
Mastectomy
Chemotherapy (Adriamycin, Cytoxan, Taxol)
Prescribed Herceptin

FAMILY HISTORY
No

BREAST CANCER GENE
No

RESOURCES
American Cancer Society
Breastcancer.org
Lance Armstrong Foundation
SHARE: Self-help for Women with
Breast or Ovarian Cancer
Young Survival Coalition

LEA SIEGEL
Makeup Artist, 57

"I'm *finally* starting to feel connected to my 'self.' It took a long time to get back to a life that didn't center around doctor appointments and health concerns. It also took years to throw out my feeling that something was 'unfair.' My true self is one that is open, and I felt as if something bad had happened to me without my permission."

DIAGNOSED
1998 and 2000
Multifocal intraductal carcinoma

TREATMENT
Lumpectomy
Mastectomy
Chemotherapy with Herceptin
Radiation
Holistic supplements
Yoga and acupuncture

FAMILY HISTORY
No

BREAST CANCER GENE
No

RESOURCES
Beth Israel Phillips Ambulatory Care Center
Dr. Susan Love Research Foundation
Gilda's Club
SHARE: Self-help for Women with Breast or Ovarian Cancer

"The community that I belong to is comprised of the young women who were diagnosed, like me, at a relatively early age. *Nothing* could possibly describe that type of camaraderie. It makes sleeping at night so much easier and living each day so much more rewarding."

DIAGNOSED

February 22, 2002, at age 25
Stage IIA invasive ductal carcinoma,
right breast

TREATMENT

Lumpectomy with sentinel node biopsy
Chemotherapy (Epirubicin, Cytoxan, Taxol)
Radiation

FAMILY HISTORY

Maternal grandmother, alive at 79

BREAST CANCER GENE

No

RESOURCES

Breast Cancer Alliance of Great
Cincinnati
Breast Cancer and Environmental Research
Centers
Breast Cancer Fund
Living Beyond Breast Cancer
Pink Ribbon Girls
Silver Spring Institute
The Wellness Community: Free Cancer Support
Groups and Cancer Information
Young Survival Coalition

If the Shirt Fits

JACQUELINE LOU SKAGGS

Apparel Designer and Activist, 45

"My experience with breast cancer has made me even
more acutely aware of the backwards ways in which a woman's
body is socially viewed and treated. Other than that
my outlook hasn't really changed. I didn't think life was short
before, and I still don't. You simply have to make
good use of your time, whether it's 20, 30, or 90 years."

DIAGNOSED
April 2000, at age 36
Stage 0 ductal carcinoma in situ,
right breast
November 2004, at age 40
Stage 0 ductal carcinoma in situ,
right breast

TREATMENT
Lumpectomy
Radiation
Mastectomy

FAMILY HISTORY
Maternal grandmother

BREAST CANCER GENE
No

RESOURCES
Breast Cancer Action
Breast Free
Cancer and Careers
The Creative Center, New York
The Songbird Branch

For full list, please visit
http://www.rebel1in8.com/resources.html

JACQUELINE LOU SKAGGS

Apparel Designer and Activist, 45

I DON'T SEE CANCER AS A "FIGHT" OR A "STRUGGLE" — I think that is misguided terminology that we've adopted over time. I weighed options regarding surgery and treatment, made decisions, and moved forward with them; the only "struggle" I engaged in was my internal conflict with the radiation (which I found archaic, harmful and disfiguring) as "treatment" to "preserve" a breast, and the annoying social/political conflicts involved with the decision to comfortably walk the earth with only one breast.

There are fears during any crisis that our minds get wrapped around. During the experience we figure out ways to preserve who we are in an effort to guide ourselves with some sense of sanity — but the cancer was nothing to "fight." To imply it's a fight is to imply that if cancer kills you then you have lost — thus you are a loser. A dead loser. That simply doesn't sit well with me.

Cancer is an event and nothing less than a "perfect storm." You either get out and then deal with the aftermath or you don't get out at all. At the end of the day the only thing you can control is your disposition during the storm.

One of the things I tried was doing a few SGK walks. I raised over $2,000 dollars, but eventually it seemed to be more about unification through marketing and product awareness than sisterhood or health care awareness. I'm all for raising money for research, but to do it through endless merchandising, meandering walks, and "save the breast" campaigns can be shallow. Instead of enlisting sympathy through a shroud of "lost femininity" and massive product consumption, a bright light could be shed on significant health care issues and causes of cancer — a more dignified, social and compassionate approach to bringing true awareness of the disease.

During my final SGK walk I was so disenchanted by the oversized issued uniform

that I created my own race T-shirt, one that embraced my new architecture instead of hiding it. Sometimes you simply have to reinvent something: how we define our sexuality, our social positioning, our careers, our perceptions of ourselves, our wardrobe, our masculinity, our femininity.

I felt that the community needed a creative perspective, a nudge "out-of-the-box." I wanted to begin a new campaign that endorsed individuality, progressive thinking, clarity and common sense. I knew that I wasn't on this island alone and that if I expressed my views on how things could be, I would find other like-minded women.

I founded the Rebel1in8 website and the Rhea Belle apparel clothing line by looking at everything I liked — and didn't — within the existing breast cancer community. The missions of both are to challenge conventions and preconceived ideologies: medical, social, and personal.

Both projects were an intuitive reaction to, not necessarily breast cancer, but the after-math. During my first diagnosis, the surgeon who performed my lumpectomy said "If you have a mastectomy, you will get an implant. No woman leaves my O.R. without reconstruction (an implant)." That she would decide what I do with my body outside of medical issues kind of blew my mind.

After my second surgery, I called the hospital "mastectomy boutique" naively inquiring about a single-cup bra. I assumed there was such an item because, after a mastectomy some women only have one breast. I was asked if I had been fitted for a prosthesis and I explained that I wasn't going to use one. There was confusion on the other end and I had to repeat my request. Finally, the voice on the other end replied — with a frustrated attitude — "No, we don't have anything like that. Why would you want something like that?"

I thanked them for their time and hung up, leaving a paragraph unsaid:

"Why would I want something like that? Because I've opted not to further traumatize my body and spirit by having yet another painful procedure that involves shoving some blob of synthetic goo under my painfully stretched flesh and muscle in the name of femininity and looking 'normal' to the world. I have no intention of wearing an uncomfortable bag-o-stuff inside of a pocketed bra. And I need support for my remaining beautiful breast. That's why I'm looking for that single-cup bra, ma'am."

I'd hung up feeling embarrassed and enraged. I was in very unfamiliar territory and that had to change — I was not going to change for it.

I called boutiques around the country, searched the internet, and found nothing. There were no clothes designed for me, so I decided to design them. I don't need to fit into the world; the world has to fit me. It's very simple. So, both ROiE and RB were borne out of an effort to affect how we embrace our bodies and our positions in the worlds around us.

I decided to look at my body as a different kind of architectural structure, not as a negative result of an event. Considering its history, my body is how it's supposed to be and nothing is "wrong" with it that needs to be changed or hidden. I have this body and it needs acknowledgment and acceptance through design. And I can tell you, the first time you wear something that is clearly made for your body, it's empowering.

I hope both ROiE and RB transcend breast cancer by creating an alternative thinking process — intellectually, spiritually, and emotionally. Not the cancer experience so much, but the aftermath has connected me to a meaningful social responsibility to explore the layers and translate the experience with sincere clarity.

PAMELA K. EMBURY

Small Business Owner, Writer, and Breast Cancer Advocate, 46

"It is amazing! I feel like I am standing beside my true self...
being alive and offering no apologies for days
that I am happy, sad, pretty or ugly. I am me, and I love me."

DIAGNOSED
Self-diagnosed in 2005, officially
diagnosed 2007 (it took two years
to get insurance approval for the
sonograms)
Invasive ductal carcinoma and ductal
carcinoma in situ, left breast

TREATMENT
Lumpectomy
Node dissection
Chemotherapy
Radiation

FAMILY HISTORY
No

BREAST CANCER GENE
Unknown

RESOURCES
Breast Cancer Network of Strength
Young Survival Coalition

An Unusual Bond

ARNALDO & VANESSA SILVA

School Foreman (Arnaldo Silva) / Assistant Program Chair of Frederick Douglas Academy (Vanessa Silva), 61 and 36

"What sparked me to not only fight the disease, but to also spread awareness, was my father. I received a lot of support and resources for women with breast cancer, but it was hard to find any support or resources for my father. I would like to make people aware that men get breast cancer too." —*Vanessa Silva*

ARNALDO SILVA
DIAGNOSED
January 2007
Stage II, right breast

TREATMENT
Chemotherapy (Adriamycin/Cytoxan, Taxotere/Cytoxan)
Mastectomy
19 lymph nodes removed

FAMILY HISTORY
Daughter and paternal aunt

BREAST CANCER GENE
Yes

RESOURCES
As there was a lack of resources for men with breast cancer, relied on daughter and doctors

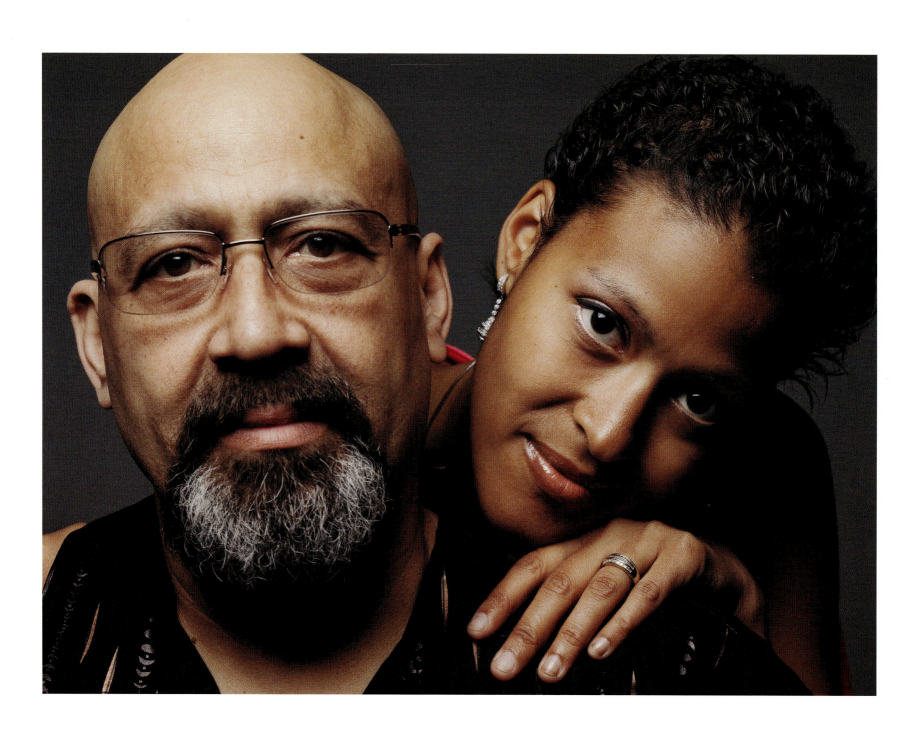

ARNALDO AND VANESSA SILVA

School Foreman (Arnaldo Silva) / Assistant Program Chair of Frederick Douglas Academy (Vanessa Silva), 61 and 36

ARNALDO SILVA

Being one of the 1% of men diagnosed with breast cancer has turned my life upside down. Most people can't comprehend how I ended up with the "Big C," let alone the "Big BC." They say "That's a *women's* disease." I felt like I had to justify how I, a man, could get this disease.

My primary doctor had assured me that the lump I felt on my right nipple was just fatty tissue. But after several months it had enlarged, and after being referred to an Oncologist, the lab work and biopsy results came back positive for cancer. As it was breast cancer, I had to take a genetic Test called BRCA. It came back positive for BRCA2, which led to my children having to be tested and my daughter finding out she also had breast cancer.

I had eight treatments of chemo, which I made it through, but unfortunately I was not able to complete the scheduled 52 weeks of Herceptin therapy; after 22 sessions the medicine had damaged 40% of my heart.

During this process, my primary support was my wife and family. There wasn't much outside support or information for men with breast cancer. All of the side effects from the chemo left me very weak, and every time I had a question for the doctors, all they could tell me was that they were treating my case as if I was a woman, which was not helpful. I did not want to participate in female support groups because there were no males present, and I felt that a woman could not relate to what I was feeling as a man. Most of the time I felt alone and depressed because I couldn't vent on how I really felt. One thing I found comforting was my faith in the Lord and knowing that He would see me through.

I would like to get the word out that men can get this disease too, and should not be ashamed about it. Cancer can attack any part of the body, whether you're a man or a woman. I think that if more men who are diagnosed with this disease come together and get the word out, support groups can be formed, money can be raised for research, and the more people will know.

VANESSA SILVA

After I was diagnosed my initial response was shock, but I just knew I had to do what was needed to make sure I removed the cancer and stayed healthy for my family. I prayed the night I found out and put all of my worries into God's hands, having faith that he would see me through, and from that moment on I went on with my everyday life.

I was very aware of breast cancer because my aunt had died of breast cancer, but never really did the full research until my father and I were diagnosed. I really liked the doctor my father was seeing and decided to see the same doctor.

My best support system was my father, because he and I did the chemo together. He knew first-hand what I was going through and how I was feeling, and vice versa. We knew we both had to be strong for each other and our families.

What sparked me to not only fight the disease, but to also spread awareness, was my father. I received a lot of support and resources for women with breast cancer, but it was hard to find any support or resources for my father. I would like to make people aware that men get breast cancer too. I know the number may not be as big as men with prostate cancer, but I just feel people should be aware.

For me personally, the whole experience has allowed me to refocus my priorities in life. After treatment I decided that I would not join the rat race again and I sought a job that would allow me to be flexible with my time, so I could spend more of it with my children. Going with that approach allowed me to find the perfect job at a public high school. There the principal allows me to work from home two days a week and I get out early enough to pick up my children from school. Who could ask for more!

VANESSA SILVA
DIAGNOSED
May 2007, at age 32
Ductal carcinoma in situ metastasized to lymph nodes

TREATMENT
Chemotherapy (Taxotere)
Bilateral mastectomy

FAMILY HISTORY
Father and paternal aunt

BREAST CANCER GENE
Yes

RESOURCES
American Cancer Society
Susan G. Komen for the Cure
Team Continuum

"I still have physical appearances of a port-o-cath in my arm, scars from surgery, a somewhat disfigured breast. But, at the end of the day, *I am alive. I am alive and doing shockingly well.*"

I WAS DIAGNOSED ON NOVEMBER 22, 2005, AT THE AGE OF 30. What society puts out there is that women should start getting mammograms when they turn 40 — I had no knowledge of young women getting breast cancer too.

At first I couldn't fully connect with most other survivors; I was frantically searching for other young women who were diagnosed as being stage 4 metastatic right off the bat (like me) that were still alive after the two year marker, five year marker, even 10 years. I found myself feeling most content in a weekly support group at UCLA that only allowed stage 4 metastatic survivors to participate. I related most readily to those wonderful women, who have struggled through many recurrences. They are my teachers.

I feel certain that the stress and pressure I experienced at my job, trying to constantly please my boss and make him proud while I worked my way up the corporate ladder, was the biggest contributing factor to waking those cancer cells up in my body. Stress along with diet, lack of nutrition and exercise and keeping everything inside which made me toxic emotionally was what triggered my disease.

My boss was so horrible to me, but I was too scared to leave my job for fear of being fired and having no money to support my family. I was also scared to go on disability because I wondered how I could support myself and my family on 60% of my salary. But my doctors said I would die within a few months if I did not make this change and get out of the toxic environment/ relationship with my boss. After trying to work through chemo for six months and almost killing myself playing Superwoman, I finally left my job and went on disability. And it was the best thing I could have ever done for myself.

My life feels so much more rewarding now than before, when I was in some ways lost and extremely unhappy. I am more satisfied with who I am today and all that I have engaged in, like my advocacy and volunteer work. I have a much more intense appreciation for every experience that life gives me and I truly value all of the wonderful opportunities, lessons and blessings that this diagnosis has created for me.

One of the biggest forms of therapy for me are my dogs. Spending time with them makes me hungry to live the best life I can, so that I can stay here and take good care of them, showering them with unconditional love. It has made me feel more connected to this world and to my true spirit. I think because I cannot have children now I view them more and more as my kids. I am a mom. I am their mom and for me, that is the most profound feeling.

I have lots more to say, but I am saving it for my own personal book which I have been working on!

DIAGNOSED
November 22, 2005
Stage IV metastatic
4 out of 20 lymph nodes positive

TREATMENT
Neo adjuvant chemotherapy (Iaxotere, Andriomycin, Cytoxan)
Lumpletomy
Radiation
Physical Therapy
Acupuncture

FAMILY HISTORY
No

BREAST CANCER GENE
No

RESOURCES
Breast Cancer Network of Strength
Living Beyond Breast Caner
Los Angeles Breast Cancer Alliance
Metastatic Breast Cancer Network
Susan G. Komen for the Cure
Young Survivors Coalition

LISA SUIT
President and Founder of Baltimore Music Conference, 50

"With chemotherapy and radiation, I fought as my community
rallied 'round, hosting a birthday party for me where
over 30 people, women and kids included, shaved their heads to
raise money and show support for me. Keeping my kids
involved in knowing what was going on at all times and a positive
attitude has allowed me to reach 10 years cancer-free."

DIAGNOSED
1996 and 2001
Small tumor, recurrence in lymph nodes

TREATMENT
Lumpectomy
Radiation
Chemotherapy

FAMILY HISTORY
No

BREAST CANCER GENE
Unknown

RESOURCES
American Cancer Society
MammoJam

"I, like so many young survivors, am not grateful for this experience. My kids lost their mom for over a year. My husband definitely lost the wife he married and has been so wonderful at adjusting to the post-cancer me."

"Other women have not been so lucky. When the older kids in my neighborhood perform in dance recitals, play a sport or even graduate, I try to take it all in because I don't know if I'll be around to celebrate that moment with my own kids. Cancer has made me more cognizant of being grateful for every day and that there are no guarantees."

DIAGNOSED
2003
Stage IIA infiltrating ductal
carcinoma, both breasts
Nodes in left breast

TREATMENT
Chemotherapy (Neoadjuvant, Adriamycin/
Cytoxan, Taxol)
Bilateral mastectomy
Avastin infusions
Methotrexate & Cytoxan

FAMILY HISTORY
Maternal aunt Patty diagnosed at the same
age I was, recurred 12 years later and died

BREAST CANCER GENE
No

RESOURCES
Caring Bridge
Melvin and Bren Simon Cancer Center at
Indiana University
Young Survival Coalition

On Knowing Yourself

CABRINI SCHNEIDER

Entrepeneur / Owner of Loftydog House Daycare, 44

"On April 13th, 2005, I was sitting on my sofa when my dog,
Sandy, jumped on my lap. Sandy caused my hand to brush against my
left breast and I felt this knot; it was as though it had
appeared overnight, I mean it was not there the day before."

DIAGNOSED
April 13, 2005
HER2 positive
Lymph node negative in left breast

TREATMENT
Chemotherapy
Intraoperative radiation therapy

FAMILY HISTORY
No

BREAST CANCER GENE
Unknown

RESOURCES
Relied on friends and family to get through

CABRINI SCHNEIDER
Entrepeneur / Owner of Loftydog House Daycare, 44

I GOT UP AND WENT TO MY PARTNER — she's a registered nurse — and asked "What does this feel like?" She felt the knot and just looked at me. The thought that this could potentially be the thing that takes me out never even occurred to me; I just said "Okay, if it is something, we need to know" and I made an appointment with a doctor.

The next day the doctor told me "You know, eighty percent of these are non-malignant," and I thought, okay, well, twenty percent is really high, that doesn't feel like a low number to me. I then called a breast surgeon recommended by a physician friend, and the first appointment I could get was for the next week. So I spent that whole weekend thinking about life, appreciations for things, where I wanted my life to go beyond this, and you know, you go through this whole "If I do die..." thing.

The breast surgeon, Dr. Eileen, did a needle-biopsy that came back negative. But the doctor thought it looked suspicious and had a hunch that there was cancer deeper in the tissue, so she scheduled me for a lumpectomy. When I found that lump on the 13th, I had no idea I'd be going through surgery and then chemotherapy within three weeks.

I had never had surgery before, and here I am lying on this table. The doctors were wonderful; they had found out I had a jazz club, so while I'm going into surgery they had jazz playing in the room. "Oh Lord," I said, "well, if I'm going to die this is beautiful, what a lovely way to go!"

After I woke up a couple hours later, we found out I'm allergic to morphine. What a terrible thing — can you imagine? It's the only part that everybody loves, and I'm allergic to it!

After that surgery they of course found out it was cancer, so then I had to go back for another surgery, a sentinel lymph node biopsy. I had this cancer that was very aggressive, a nine out of nine, which meant had it jumped outside the lump, it would have just been an aggressive crazy thing, much like me. So they got it out real quick. Next I find out I have to go to this chemotherapy thing.

I had this wonderful oncologist, Dr. Chung, who told me "Well, here are the odds. You can have chemotherapy, and the percentage of return is — " I think she said ten percent. Don't quote me because I can't remember. But people were telling me "You don't want that poison in you, you should go to a holistic lab." Now all of those things are fine, but if you decide to take the holistic route, you have to know who you are first. Can I be a holistic person, can I just eat bean sprouts and carrots everyday? Hell no. So I said, I'm going to have some poison.

Now did I tell myself I was going to this place every day to be poisoned? Absolutely not. I told myself "I am going for a liquid cleansing. My body will be cleansed, every day, and everything that's going wrong is gonna go away. Once you get this, this is a new day!" So that's how I looked at chemotherapy.

Then there was the radiation. I was able to have something called IORT, or Intraoperative Radiation Therapy, because my doctor ran the USC Breast Cancer Department and was in charge of this new treatment. IORT was still in trials at the time, and it was for early-detection cases. It involves opening you up, going back into the area where the lump was and doing the radiation at the site, one time. So, another surgery, I was like "Here we go again."

If I could give advice to women who are about to go through what I went through, well, I could fill a book, but since it won't all fit here I'll just mention a few things. The first might sound minor, but it's important: As they say, when you're on chemotherapy do not eat anything you love, because you will definitely throw it up. Do not eat anything from your favorite places — create new places called "chemo places," those will be your "cleansing" spots, and afterwards you'll never wanna go back there!

The other thing I want to say to newly-diagnosed women is: You do not claim this thing. It is just something that's passing through you. It is not who you are, and it is not who you will be. It is just passing through. You do not say I have cancer; you have a lump that has cancer.

Do not claim it, and every single thing that happens after you are diagnosed — whatever you put in your brain is gonna be very, very important. Everything you look at becomes different. Don't look at no sad-ass movies about a woman who has cancer and dies. HELLO! You don't want that! All the information that you get has to be uplifting and upbeat.

"I did not get a second opinion and I truly wish I had. Not because I wanted a different diagnosis but because I would have liked to find out more about my options and my risks."

DIAGNOSED

January 2006
Stage IIIB inflammatory breast cancer
Invasive/infiltrating ductal carcinoma,
right breast

TREATMENT

Neoadjuvant chemotherapy
(Taxotere, Herceptin)
Mastectomy
AC Chemotherapy (Doxorubicin,
Herceptin)
Radiation

FAMILY HISTORY

Maternal grandmother

BREAST CANCER GENE

No

RESOURCES

American Cancer Society
FORCE: Facing Our Risk of Cancer Empowered
Keep A Breast
San Diego Breast Health Coalition
Young Survival Coalition (San Diego)

Finding Your Own Community

MICHELE FORSTEN

College Communications Director, 55

"At first, I couldn't find a community. I went to a group for newly
diagnosed women and I was the only lesbian there. You
might be thinking, 'Why should that matter?' More on that later,
but essentially the group was helpful in some ways — especially one
of the facilitators, who was a very good role model
for me on how to live one's life after a cancer diagnosis — but
in other ways, our needs were totally different."

DIAGNOSED
February 1, 2002
Stage I invasive ductal carcinoma, right breast

TREATMENT
Bilateral mastectomy
Salpingo-oophorectomy
Tamoxifen
Acupuncture
Supplements (tumeric, fish oil, vitamins)

FAMILY HISTORY
Mother diagnosed at 42, died at 46
Maternal aunt diagnosed at 80,
died at 92

BREAST CANCER GENE
No

RESOURCES
Long Island Lesbian Cancer Initiative
Mautner Project
National LGBT Cancer Network
New York City LBGT Center
The Annie Appleseed Project
The Breast Cancer Listserve

THE CHANCE OF DEVELOPING INVASIVE BREAST CANCER AT SOME
TIME IN A WOMAN'S LIFE IS ABOUT 1 IN 8.

MICHELE FORSTEN
College Communications Director, 55

I BEGAN LOOKING FOR A LESBIAN CANCER SUPPORT GROUP, and found that the groups that did address women who partner with women — the American Cancer Society, SHARE, Gilda's Club, and the NYC LGBT Center — were mostly defunct because nobody was signing up for them. It seemed incredible to me that a city as large as New York didn't have the services I needed; so, being a writer, I wrote an article about this sorry state of affairs. It was published in Gay City News and, soon after, it was put on Dr. Susan Love's website.

To my surprise, I received e-mails from lesbian cancer survivors from all over the U.S., the U.K., and Australia. One from the U.K. wrote: "My main concern with my treatment is that I feel I can't be myself; that if I was open about being gay, I might meet with prejudice from my medical team." Another, from the Midwest, said her partner of 17 years walked out on her while she was in treatment. She said she couldn't talk to her support group about this, because she wasn't "out" to them.

I also received phone calls from social workers, one of whom was Elizabeth Tarr from the American Cancer Society. Along with my good friend Mindy Schiffman, a psychologist who did her post-doc at Sloan-Kettering, we assembled a group of health professionals to discuss the situation.

We eventually became the co-chairs of the New York City Lesbian Cancer Support Consortium. This group of health care professionals was the catalyst for the New York City LGBT Center starting the Lesbian Cancer Initiative, which offers individual counseling and support groups for survivors and caregivers. I joined the survivors' group and after a year as a participant, became a co-facilitator. With this group I finally felt a sense of community. We can talk about things that are difficult for those who haven't had cancer to truly understand. Afterwards we often go out to dinner, and while very difficult things are discussed

during the group, dinner is a time to joke and laugh, which is a good way to end the evening. Some group members have become good friends of mine.

I have involved myself in raising awareness of the unique circumstances faced by lesbians with cancer through my writing and activism. I wasn't much of an activist before I had breast cancer, but I feel my current activities enhance my life and hopefully help others.

Heterosexual people might wonder, "Cancer is cancer. Why does it matter if you are a lesbian or not?" Some of the issues we grapple with are specific to women who partner with women. For starters, in the first groups I attended, I was the first lesbian some or all of them had ever met, and I felt like I had to educate them instead of receiving support from them.

Secondly, many of the women spoke about how their husbands didn't find them attractive anymore and didn't want to touch them. I had the opposite problem — my partner still found me attractive, but I didn't want her to touch me. I also didn't want to touch her breasts because it was a reminder of what I had lost.

Another issue is whether to come out to doctors and medical staff, or instances of homophobia related to our disease, for example. When I came back to work after the surgery, I had to deal with reporting someone who had been sexually harassing me at work before I was diagnosed. While I was on leave for the surgery, my harasser had even said to his secretary, "Why is she having the surgery? She's a lesbian. It's not like she needs to use them or anything, not like a real woman would." That remark never would have been said about a heterosexual woman! I resented the stress that I was put through when I should have been recovering from my surgeries, and the whole ordeal ended up having to be dealt with at the New York State level.

I've since heard other stories as well, like that of Micki and Peggy, a lesbian couple in their 40s who have been together for 16 years and live in a small community in Virginia. Micki underwent breast cancer treatment for some time, but the hospital staff there refused to treat Peggy as her spouse, even though the couple named each other on their health proxies and powers of attorney.

"There have been several of Micki's surgeries when they didn't come out to tell me what's going on," Peggy told me. "So I sat for hours thinking she is still under when, in fact, she had been in recovery for hours, or I had to find out where they've put her and wait outside the door." Peggy, who herself is a nurse, added, "I had to do all of Micki's care in the hospital sometimes because the nurse working that shift didn't want to touch her, simply because she's a lesbian." At first, Peggy said, she tried passing herself off as Micki's sister, but couldn't keep up the charade.

It is clear to me that only by being out can lesbians hope to get the full range of services they need and deserve. To serve this end I have made it my business to be one of the faces of lesbians with breast cancer in New York City, appearing on radio programs, telephone call-ins, speaking at conferences, whatever it takes.

The way that I personally coped was to focus on writing about my breast cancer experience. I am a journalist by training and had been published before, but I had a new sense of purpose. The results can be seen on my website (http://www.micheleforsten.com under "essays"). So, while I've plateaued in my public relations career, I have gotten satisfaction in my other pursuits, using my writing and organizational skills to help create change.

LOIS D. FISHER

Administrator at Alcoholics Anonymous World Services (Retired), 72

"I consider having breast cancer
a spiritual experience in that it has given me
a vivid appreciation for life. My partner
and I are traveling a lot, and I no longer worry
about money. The truth is that I've
never been happier although that probably
sounds very strange."

DIAGNOSED
August 1999
Invasive estrogen positive
HER2 positive
3 positive nodes in right breast

TREATMENT
Lumpectomy
Chemotherapy (Taxol, Herceptin, Cytoxan, Adriamycin)
Radiation

FAMILY HISTORY
No

BREAST CANCER GENE
No

RESOURCES
Gilda's Club
St Vincent's Cancer Center

"After you go through cancer and they tell you that you are in remission, you feel like you have won the lottery. I felt a little lost in my own skin — I was thankful to be alive, but I didn't feel like I fit back into my old life. To me the rest of my time here on Earth is 'free time.' Cancer was an invitation for me to really live, to allow myself to slow down and enjoy it."

DIAGNOSED

May 16, 2006, at age 37
Infiltrating ductal carcinoma, (grade 1 out
of 3 on aggressiveness), no lymph node
involvement, had not metastasized

TREATMENT

Double mastectomy
Tamoxifen

FAMILY HISTORY

No

BREAST CANCER GENE

No

RESOURCES

American Cancer Society
Image Reborn classes at Kaiser
Permanente Los Angeles
The Foundation: Community and
Family Health
Young Survival Coalition (San Diego)

SHEILA M. SLAUGHTER

HR Project Manager, 46

"Post-cancer, I have a new appreciation for
my physical self…I will never again take my body for
granted. Of course, my cancer experience
has prompted me to change my diet, make healthier
food choices, and work out regularly.
I am stronger than I have ever been, *it's thrilling*!
I have become attuned to my body, listening, feeling,
and reveling in every little nuance."

DIAGNOSED
June 29, 2006
Adenocarcinoma in right breast

TREATMENT
Lumpectomy
Chemotherapy (Cytoxan, Adriomycin, Taxol)
Radiation
Tamoxifen

FAMILY HISTORY
No immediate family, but 76-year-old aunt,
a 10-year survivor, passed away from breast
cancer three months prior to my diagnosis

BREAST CANCER GENE
No

RESOURCES
CancerCare
Intercultural Cancer Council
Kessler Rehabilitation Center
Lance Armstrong Foundation
Living Beyond Breast Cancer
National Cancer Institute
National Coalition for Cancer Survivorship
New York University Cancer Institute

Too Young for Breast Cancer

MAIMAH KARMO

President and Founder of Tigerlily Foundation, 36

"I was misdiagnosed. The doctor told me that I was too
young to have breast cancer, and after an unsuccessful biopsy and
aspiration, she sent me home and told me to come
back in six months. The mammogram was also false. I asked
for a biopsy and she wouldn't give me one. When I went
back for a follow up, the lump had doubled in size. I asked for
a biopsy again, and she refused. She told me
to go to the nurse and schedule another aspiration."

DIAGNOSED
February 29, 2006
Stage II invasive ductal carcinoma,
right breast

TREATMENT
Lumpectomy
Chemotherapy (Andromycin, Cytoxan, Taxol)
Radiation

FAMILY HISTORY
No

BREAST CANCER GENE
No

RESOURCES
Breastcancer.org
Breast Cancer Network of Strength
Young Survival Coalition

MAIMAH KARMO

President and Founder of Tigerlily Foundation, 36

I WISH I HAD GOTTEN A SECOND OPINION, BUT I TRUSTED MY DOCTOR. I've since discovered a lot of other young women like myself are initially misdiagnosed.

I had lived a healthy life, and as far as I knew, I wasn't supposed to get cancer. But I was eventually told that it was Stage II, it was aggressive, that my Elston score was high, I would lose my hair, wouldn't be able to have more children. It was so overwhelming — I was hearing words like recurrence, receptors, reconstruction, surgery, chemotherapy, toxins, and on it went. It was like not being able to wake up from a very bad dream.

During treatment my mother was my primary support system, and so many family members, friends and relatives spent time with me and helped with everything from buying groceries to taking care of Noelle to taking me to my chemo treatments.

My grandmother was a source of great inspiration for me. At 94 years old, she began having a series of strokes. This was during the time of my treatment. Once I was visiting with her while she was ill and as I was leaving, she was mouthing something, but I could barely hear her because she was tired and not able to project her voice very well. I leaned close to hear her; she was thanking God for his many blessings, for her life and health. She said this as she lay in a hospital bed, unable to move barely a muscle in her body. I was so moved and humbled by her ability to be grateful, even as she lay facing the end of life. It was an amazing life testimony for me. Sadly, she passed away right after my treatment.

My daughter was my main source of strength. I knew that I couldn't leave her and that I had to not only heal physically, but also ensure that my life would be a testimony to how a woman is supposed to be and live. She would climb into bed, color and play with me. She would hold my hand when I was sick and she never once, even when I was bald, never once was embarrassed of my bald head or the different physical changes I experienced. At my lowest point, when I no longer felt even remotely female — I'd lost weight, all of my hair, and was facing infertility due to my chemo — I was so depressed and as I looked into the mirror one day, aghast at how I looked, I felt her behind me. When I asked her what she was looking at, she told me that I was beautiful and that she loved me. She could see through everything and really see me. She, at nearly four years old, taught me what it meant to really love someone. I was floored by her honesty, purity and innocence. I looked in the mirror trying to see what she saw and smiled.

After going through everything we go through, when you finally reconnect with yourself, it is like finding yourself after years of forgetting who you really are. I believe that many people forget who they are somewhere in their childhood. It is like having this joy and clearness in your heart, it is great. It's smiling as the wind kisses your face, and at a stranger on the street. It is just being happy that you exist. It is like falling in love, really falling in love, but with yourself!

During my second round of chemotherapy, I founded a breast cancer organization called Tigerlily Foundation (www .tigerlilyfoundation.org). The goal is to educate, empower, advocate for and provide hands-on, ground level support for women affected by breast cancer. There are many large organizations that fund research and scientific-based organizations working to find a cure; what Tigerlily Foundation endeavors to do, on the other side of that, is provide support to women who are living with breast cancer today. Until there is a cure, thousands are being diagnosed and families have no way of anticipating many of the challenges they will encounter going through this time.

There was an incident where a woman saw my story in a magazine, and read where the doctor had told me that I was too young and I went back and insisted on a biopsy. Well, she was a survivor as well and had found another lump in her breast. She had told her doctor and he did not think it was cancerous since she had recently finished chemo. After reading my story, she took the magazine back to her doctor's office and told him she wanted the lump tested. She was rediagnosed with breast cancer. That had a profound impact on me. It made me realize that my experience could save lives. How was I to know that through my pain and struggle that I could help save someone else and give others strength and courage? I didn't initially, but it was becoming clearer now.

And as for the "sorority" of women diagnosed with breast cancer, I feel as if I am part of an amazing, inspiring group of women now. I would never in a million years have imagined when I was diagnosed that the experience would bring me such joy or bring me to find myself. I have so many new friends who are doing amazing things and creating lives that they might not have created had they not been diagnosed. They are like my sisters and they are all so strong, and so determined, that I am humbled by their strength.

There is something about a fellow survivor that gives you the feeling that they "know" and that they "get it." I wish I could pass on the energy of a survivor to all the women I know and love. I hope telling my story here will contribute to that.

SUSAN SCHWALB
Artist and Writer, 65

"I was lucky that I was in good shape prior
to being diagnosed, so I was able to regain most of my
previous abilities — I still swim half a mile a
day, six days a week. I got back the use of my arm
and I was grateful for that.

"My friends provided a great support system,
and my husband was fabulous throughout my cancer.
He came to every appointment, stayed with
me in the hospital for each and every surgery. The nurses
gave him the Husband of the Year award but he says
he just did what anyone would do. During
my recovery he made me three meals a day, did all
the errands until I found friends to help him out.

"Today he says I am as beautiful as ever; that
does make me feel that all my scars and disfigurement
are unimportant. I think one's partner is key
to survival in these kinds of moments. I am grateful."

DIAGNOSED
July 2005
Ductal carcinoma in situ

TREATMENT
Wide incision surgery
Mastectomy

FAMILY HISTORY
Mother and maternal grandmother diagnosed
in their 80s
Paternal aunt diagnosed and her daughter
contracted breast cancer just a year before

RESOURCES
Beth Israel Hospital (Boston)
Breast Cancer Network of Strength
24-Hour Hotline
BreastCancerStories.org

BREAST CANCER GENE
No

Balance and Harmony

DELIA GAY DE PERIO

Former Nurse Turned Oriental Medicine Doctor, 52

"I was a registered nurse and was married to a surgeon, but I had no personal experience with cancer; I didn't know anyone who had cancer, only the patients I had taken care of in the hospital. I was not aware of the prevalence of breast cancer, and of course, I didn't think it would ever happen to me.

"When I was diagnosed, I immediately went into a state of emotional numbness. When I heard the word 'cancer,' it's as if my spirit left my body — I suppose it was so traumatic that my spirit had to detach to protect myself. The numbness lasted for days, and I kept waiting for that phone call, 'Oh, sorry, we got your slides mixed up with somebody else's. You don't have cancer after all!'"

DIAGNOSED
September 1990, at age 32
Stage I invasive intraductal carcinoma

TREATMENT
Lumpectomy
Chemotherapy (Adrianycin, Cytoxan)
Radiation

FAMILY HISTORY
Maternal aunt was diagnosed and died
from breast cancer

RESOURCES
Healing Odyssey

BREAST CANCER GENE
Unknown

THERE ARE ABOUT 2.5 MILLION BREAST CANCER SURVIVORS
IN THE UNITED STATES.

DELIA GAY DE PERIO
Former Nurse Turned Oriental Medicine Doctor, 52

THAT CALL NEVER CAME, AND VERY SLOWLY, I RECONNECTED WITH MY SPIRIT to prepare for what I knew was going to be a battle. Because I had worked at the hospital and most of the cancer patients I had seen there were very ill, I equated cancer with death. I thought I was going to die, but I was desperate to live, so I dug in and reached deeply for every ounce of strength and will in me. I was going to battle this disease and conquer!

After that battle — which was the fight of my life and its own chapter, separate from this story — I went back to the Neurology/Neurosurgery unit that I worked at, and it was very difficult. I was so emotional, very sensitive to everything. Every brain tumor patient I took care of was a reminder that cancer affects so many people. I remember taking care of a young 24 year old who had a brain tumor. His family was close to him and his twin would come to visit. I was always going to the bathroom in tears — I kept saying, "Why are they getting younger? This isn't fair!" I became a very sensitive and compassionate nurse, because now I had experienced being a patient.

Eventually I left nursing to make a difference earlier in people's lives. While working as a registered nurse for an extremely busy trauma center, I saw the most severe cases of disease and its effects. I saw the impact of how one's life can deteriorate from neglecting one's health. I was frustrated because I was reaching the patients frequently at the end stage of their disease process; I remember frequently thinking, "If only we had reached them earlier on."

Rather than rescuing patients when they are in crisis, why not teach them ways to become healthy and maintain their well-being? When patients are already severely ill, damage is difficult to reverse; why not get to them earlier so that they can be guided into a lifelong regimen of health? I then began to look into Oriental medicine.

At first I did not understand it, and resisted it just as other Western medicine practitioners would, comparing it to the background that was familiar to me. Oriental medicine is a way of life, a philosophy of being and doing, a complete and whole system of medicine; once I accepted its unique, holistic philosophies, I finally understood and appreciated it. What impressed me most about it was its holistic approach of science and philosophy, balance and harmony within each of us, and between us and our environment.

As our lives have become complicated and fast-paced, Oriental medicine is about getting back to simplicity. For instance, we know the importance of eating clean, healthy, natural foods; but it's not just the foods, it's also the state of mind you're in when you take your meal. Are you eating in the car, rushing through the meal to get to a meeting? Are you dwelling on the stresses of your life? This stressful emotional state affects your mind and your body. Oriental medicine helps you to bring balance and harmony into your life. It's a holistic approach to wellness in the body, mind, and spirit.

As for how Oriental medicine can help vis-a-vis breast cancer, there are several ways. Firstly, there is prevention, a way of living your life to preserve balance and harmony in your physical, emotional, and mental/spiritual health. If you develop an illness, Oriental medicine (acupuncture and/or herbs, and other modalities of treatments) can help to restore health.

Western medical doctors are cautious or skeptical about Oriental medicine. When they are treating a cancer patient, it becomes complicated, and the patient is usually urged not to add any "alternative" treatments. The cancer patient usually doesn't visit me until the completion of their medical treatments, which is a shame, because Oriental medicine can augment conventional medical treatments and can help to alleviate the side effects of chemotherapy and radiation. It can also help to improve the immune system, help the patient with fatigue, improve sleep, alleviate pain, alleviate nausea, reduce stress and harmonize emotions, help with postmenopausal symptoms, help relieve anxiety, and help to improve quality of life and well-being.

When I see a patient for the first time, I spend a great deal of time assessing his/her health regimen. What are they eating? Are they exercising? What are the stresses in their life and how are they coping? Do they believe they have emotional support? What is their purpose in life? What are they passionate about? What lights them up? How can I inspire them, empower them to take responsibility for their life? And this is before the acupuncture treatment even gets started.

Then I take into account their history and physical examination. What are the signs and symptoms? What medications/supplements are they taking? I come up with an oriental medical diagnosis, and then plan to treat the "branch" and or "root" of the problem. For instance, if the patient is seeing me for back pain, I will provide treatment to alleviate the back pain (the "branch" of his problem), but will also, like detective work, get to the "root" of why he/she is having back pain (the real source of the disorder or imbalance). I would like to emphasize that treatment is individually tailored. Everyone is unique and treaments are individualized.

Right now there is Western Medicine, Eastern Medicine, Alternative Medicine, Complementary Medicine, and now Integrative Medicine. Wouldn't it be great if there were no distinctions, if what we did for the patient was just called *Medicine*? Because there are many modalities of healing. Acupuncture, herbs, supplements, nutrition, detox, excercise, stress managment, yoga, meditation, *tai chi*, *qi gong*, aromatherapy, prayer, support groups, art or music therapy, health education, naturopathy, homeopathy, chiropractics, etc. all can help to maintain health. Wouldn't it be great if insurance companies required and covered education and lifestyle modification and treatments for health and well-being?

"I had retired in August of 2001 and gotten married on Christmas Day 2001, ready for a new life. Then, 'BAM' — I was diagnosed with breast cancer in July 2002.

"I am taking this opportunity to reach out and help others get through their breast cancer journeys. By being open and sharing my experience, [other] women realize that this dreaded disease is real. However, there is life after breast cancer. I am extremely interested in women of color, because we have the highest mortality rate.

"You can say I am a survivor on a mission."

DIAGNOSED
July 2002
Ductal carcinoma in situ
Calcifications in the milk duct

TREATMENT
Mastectomy

FAMILY HISTORY
No

BREAST CANCER GENE
No

RESOURCES
Kaiser Permanente (CA) Breast Buddy Program
Living Beyond Breast Cancer
Women Reaching Women

"I knew of breast cancer, but I thought it
happened later on in life — not in your 20s, when
you are just coming into your body."

"After being diagnosed, I thought 'All right,
I am 22 and these are the cards I have been dealt. I am
young; I am a fighter; now what is my next
move going to be? Where do I go from here?'"

"I know myself better now as a person.
And I now know I have the strength and courage to
stand up to anything thrown my way.
I don't ask 'why;' I just smile and move on."

"For advice I would say, 'No one knows
when their time is up, so try not to listen to the
statistics. Live every day to the fullest, and
make sure your family and friends know how much
you love them and care for them, and
be grateful that you have this time together.'"

DIAGNOSED

August 30, 2005, at 22
Stage III ductal & lobular Feature
11/12 positive nodes, right breast
Metastasized to the brain and lungs

TREATMENT

Chemotherapy (Cyclophosphamide, Fluo-
rouracil, Epirubicin, Carboplatin, Pacitaxol,
Hercepetin, Taxotere, Abraxane, Tykerb)
Double mastectomy
Radiation

FAMILY HISTORY

No

BREAST CANCER GENE

Unknown

RESOURCES

Metastatic Breast Cancer Network
Young Survival Coalition

COURTNEY LERCARA ZINSZER

Owner and Founder of Pinkwings.com, 45

"I wouldn't re-do my life any other way. I have had amazing experiences as a breast cancer survivor. I have walked from Boca Raton to Miami, Santa Barbara to Malibu, Enumclaw to Seattle…. I have worked in the slums in Sri Lanka with other young breast cancer survivors to build homes, I have participated in 24-hour Relay for Life events with my family. I have a great life!

"After my 2nd diagnosis, I was so angry…and then one morning I saw Jesus and angels on the ceiling. That vision brought peace into my life."

DIAGNOSED
1996
Infiltrating ductal carcinoma, right breast
1998
Infiltrating ductal carcinoma, left breast
ERPR positive, HER2 negative

TREATMENT
Lumpectomy
Lymph node dissection
Chemotherapy (Adrio and Cytoxan)
35 rounds of radiation
Mastectomy
Prophylactic bilateral salpingo-oophorectomy

FAMILY HISTORY
No

BREAST CANCER GENE
Yes

RESOURCES
American Cancer Society
Avon Foundation FORCE: Facing Our Risk of Cancer Empowered
Dr. Susan Love Research Foundation
Susan G. Komen for the Cure
Young Survival Coalition

DARLENE FOUNTAINE
School Administrator, 46

"My motto is 'Just do it!' Through my entire experience, people could not believe how calm I was. They expected me to break down or something. I realize that life is filled with challenges. You have to get through them."

"I really hate it when people feel sorry for me. I hated the 'How are you feeling?' Or the 'You poor thing,' look. *Get over it.* I believe in quality of life. If something stresses me out too much, I try to get rid of it when I can. It is a blessing to be here!"

"As I think more about it, it was hard to tell what my real self was, as I had been pregnant the year before my diagnosis, and really, who are you really the first year as a sleep deprived mom with crazy hormones? I sort of viewed my year of treatment as another strange total body experience like pregnancy. It took the same amount of time. In one I gave life, and in the other I saved my life."

DIAGNOSED
1997
2 small tumors in left breast
1 positive lymph node

TREATMENT
Lumpectomy
Chemotherapy (5FU, Cytosin, Methotrexate)
Radiation

FAMILY HISTORY
Mother died of breast cancer at age 50, grandmother at age 80 and sister is a survivor (diagnosed at age 37, now 45 years old)

BREAST CANCER GENE
Unknown

SARINA SALIERI-HOLBORN
Homemaker, 39

"I was in the middle of planning my church wedding when I was diagnosed. Talk about throwing a wrench in things!"

MY TWO SISTERS, DIANA AND GRACE, WERE SITTING NEXT TO ME on the sofa when my doctor called. I answered and heard his voice saying "Bad sign, blah blah blah, malignant, blah blah blah...." I quickly handed the phone to my sister Diana and got up and started cleaning the condo. I picked up magazines, took cups to the kitchen, cleaned off the countertops. I can do this, I know how to clean up; I don't know how to deal with being told I have cancer. I was a healthy 25-year-old on a Sunday.

Six days later, I was recovering from a lumpectomy and feeling pretty rough.

My husband Steve was a rock. As family would come to visit, Steve stopped them at the door and told them to leave their tears there. He knew that I didn't need sadness around me — I needed help and support. He never wavered in his strength and I will always appreciate how he dealt with things.

For my second diagnosis, it was a completely different experience. I was now 32 with three beautiful children. The minute the tech came into the room I knew, by the look on her face, that it was back. I told her it was going to be okay, I said "Don't worry, I'll be fine." I had to be. My husband and my kids needed me. I wasn't sad, I wasn't even scared. This was just one more thing that I had to take care of and get back to my family. No problem.

We are all given challenges in our lives, whether physical, mental, or spiritual. I believe that how we deal with the challenge makes us who we are. I am not my cancer.

I am a strong, happy, caring, fun-loving sister, daughter, wife, and mother.

I found that there are stages that we go through — there's disbelief, anger and sorrow among others. It took time for me to be able to look at my scars and not feel the pain anymore. Recovery is a process.

As with many survivors I have encountered, my diagnosis has completely changed my life's views. I realize stuff happens that we have no control over and if we cry about it or laugh about it, it doesn't change it. I had cancer. I don't now. Sitting around asking why doesn't do anything but waste time, and every moment is precious.

DIAGNOSED
1995, at 25
2003, at 33
Stage I tumor, left breast

TREATMENT
Partial mastectomy
Chemotherapy
Radiation

FAMILY HISTORY
No

BREAST CANCER GENE
No

RESOURCES
Michelle's Place: Breast Cancer Resource Center
The Breast Care Center (Orange, CA)

Better to Laugh than to Cry

MEREDITH NORTON

Author of *Lopsided: How Having Breast Cancer Can be Really Distracting, 39*

"After being diagnosed, I wasn't that upset — I'd had a really full life, those 34 years, and a ton of life insurance. I mean I wasn't thrilled about it, but I was happy I'd lived my life up to that point as fully as I had. Without my son I probably wouldn't have gotten treatment at all. I think that the state of medicine in this culture is out of control. We try to cure everything. If I didn't think my son would suffer because of it I probably would have just ridden it out without treatment. Luckily, I had my son so I can still get treatment and stand here feeling superior at the same time."

DIAGNOSED
March 2004
Stage III inflammatory breast cancer,
right breast

TREATMENT
Chemotherapy
Herceptin
Surgery
Radiation

FAMILY HISTORY
Mother diagnosed and doing well

BREAST CANCER GENE
No

RESOURCES
I had so much help from my family that I
didn't seek outside help

MEREDITH NORTON

Author of *Lopsided: How Having Breast Cancer Can be Really Distracting*, 39

AT THE TIME OF DIAGNOSIS, I ALREADY FELT LIKE MY BODY WAS SOME FOREIGN OBJECT THAT HAD KIDNAPPED MY MIND: I'd been pregnant and was breast feeding; I hadn't been able to sleep on my stomach for over a year and a half; my boobs were making food; I'd gained 80 pounds while pregnant; my body was in shambles. I actually handled the treatment itself very well, physically and emotionally, but much of that was due to the fact that the body I was treating seemed so foreign. The breast they removed looked nothing like the breast I'd had before pregnancy, I didn't feel any attachment to it. But I did get tired, and lose my hair and all that. I started feeling more myself when the hair grew back, but it took almost two, even three years for my energy level to recover.

I started writing *Lopsided: How Having Breast Cancer Can Be Really Distracting* between my twice-daily radiation appointments. I wrote it by hand in a spiral notebook at the local public library and it took six weeks. All of my friends and especially my grandmother had always encouraged me to write because I'm such a blabbermouth storyteller. I'll be very California now and say that the process was "amazingly organic." It really just happened without much force or effort.

I thought the whole experience of what I went through was absurdly funny. Even the really poignant moments were hilarious to me. Plus, it is much easier to laugh about stuff than cry. I don't think I could have approached it seriously. I don't think I approached my treatment seriously. If I hadn't had the most lethal and aggressive form of breast cancer known, the one with the worst survival statistics, I probably would have blown the whole thing off. It had to be this horrible just to get me to focus.

The good thing about me having had cancer was that I wrote the book and now when people ask me what I do for a living I have a quick answer: I'm a writer. Before that, I was content, but a little aimless. Luckily cancer and career came just when I started aging, so I don't have to be that middle-aged woman with nothing going for her.

But seriously, when you are sick, people often give you the space and latitude and free time to really reflect and express yourself. As an adult there is almost no other way to really get a big chunk of time just for you, like months and months. It is wise not to waste it.

..

BOOK EXCERPT FROM *LOPSIDED: HOW HAVING BREAST CANCER CAN BE REALLY DISTRACTING*, CHAPTER SEVEN

The next day we met my three doctors with three very different personalities. My outdoorsy ob-gyn with the adorably sunburned nose, Dr. Lowery, had diagnosed me and passed me over to the surgeon, Dr. Ree. Dr. Ree insisted that I call her by her first name, which I never did, and was full of hugs and assuring hand squeezes. She gave me her home phone number and returned my pages immediately, even from the operating room. She seemed to be more concerned for me than I was. Dr. Yuen maintained a professional distance and spoke in measured and precise language. I loved talking to her because she had obviously learned English from a textbook, but was polishing it with the aid of somebody who'd grown up in the San Fernando Valley. She described my lymph nodes as "totally funky" and said my tumor should be "like, less humongous" after chemo.

My father researched their backgrounds and verified that they all had excellent training and reputations. Despite their youth (none of them was even forty) they were well-regarded leaders in their fields. We hung on every word, wrote down every suggestion, and felt confident. None of them inspired the dread I felt when the specialist was called in to see me about my migraines at the French hospital. When he appeared two security guards pushed him to the door. "There is no free dinner for you in here. Out!" He had to correct them, saying he was a neurologist, not a homeless man.

Time not spent at the medical center was spent wallowing (imagining all the things that weren't going to happen, like me walking in on my preteen son masturbating) and lying to our friends, saying [my husband] Thibault had flown in for [our son] Lucas' birthday party. It would have been much easier to go ahead

and tell everyone, not just family, what was happening, but neither of us wanted to ruin Lucas' first birthday. Even though canceling the party would have given us more time to pity ourselves, all the statistics predicted that we might not get another opportunity to celebrate as a family. So instead, we dragged ourselves around town, pretending nothing was wrong besides jet lag, ducking out of conversations into restaurant bathrooms to cry into our hands.

The invitations were shaped like rocket ships, but should have been shaped like martini glasses with a caption of "Bottoms Up!" The party turned out to be more of a happy hour than anything else. My family, in the WASP spirit we embrace, drank all the alcohol in the house and then went out and bought more. My sister, with Phyllis Diller's delivery, said, "This is the first birthday I've been to where we should have taken people's keys."

Lucas cried the whole time and clung to me like a tick. My brother and his wife raised suspicions by moping considerably less than usual. When we sang "Happy Birthday" it sounded like a funeral march, so much so that we had to start over, which coaxed the first genuine laugh out of any of us all day. Our guests were confused and their early departures made it clear they regretted coming.

Rebecca had no idea what was going on, so the second everyone else left she cornered me and asked, "What the f-u-k-c (she's dyslexic and her daughter was playing nearby) is going on?"

"I have cancer."

"That explains your lame-ass party."

One of Rebecca's lifelong complaints about me is my persistent lack of emotionalism. The last few days I'd been an emotional wreck, despite my efforts to conceal it. "You got choked up at the gas station." That was when I realized my own extinction would precede fossil fuel technology's. "And that kid, with the crazy 'PIPM' gold teeth. Even I saw they were misspelled and you didn't say anything. You're distracted. I knew something was wrong. And it wasn't no f-u-k-n jet lag." She wiped her eyes. Then she hugged me really tight for extra long.

JANINE MCMILLION
Attorney for McMillion & Hirtensteiner, 42

"My strength came from the life I had just received right before my diagnosis. I married the man of my dreams, had my job offer — years of hard work had paid off and I was not about to let something the size of a pea win."

DIAGNOSED
September 26, 1996
Stage II infiltrating ductal carcinoma
3 positive lymph nodes

TREATMENT
Bilateral mastectomy
Chemotherapy (Adriamycin, Cytoxan, Taxol)

FAMILY HISTORY
No

BREAST CANCER GENE
Yes

RESOURCES
The Cancer Legal Resource Center
(Los Angeles)

TRACIE METZGER

Founder and President of Pink Ribbon Girls, 39

"Young breast cancer survivors are encouraged by
their shared experiences, to educate and inspire others to
grow and live beyond breast cancer."

DIAGNOSED
2000, at age 30
Stage I invasive ductal carcinoma,
left breast

TREATMENT
Lumpectomy
Chemotherapy (Adriamycin/Cytoxan,
Taxotere)
Double mastectomy

FAMILY HISTORY
No

BREAST CANCER GENE
No

RESOURCES
American Cancer Society
Susan G. Komen for the Cure
Young Survival Coalition

BARBARA ANN BOYER

Executive Director for American Council of the Blind, 61

"Over the years I felt as if I'd basically given myself away, bit by bit, and there was no me; I was on this Earth only for others. But this past year has afforded me such an extraordinary personal journey, one that brought me to realize that I do have my own life, that it is of great value, and that I have touched the lives of so many who have, in return, given me love, support, and courage.

"Now I feel I truly have so much more to give, so much more of life to experience, and so much more joy in each and every day."

DIAGNOSED
August 2007

TREATMENT
Lumpectomy
Double mastectomy

FAMILY HISTORY
No

BREAST CANCER GENE
No

RESOURCES
Colorado Breast Cancer Resource Directory
Susan G. Komen for the Cure

My Two Daughters

HEATHER SALAZAR

Mother, Wife, Activist, Social Worker, 34

"We adopted our fourth child, Lexi, and her
mother died of breast cancer at the young age of 24. So I was
painfully aware of breast cancer before my diagnosis."

DIAGNOSED
December 8, 2004, at age 27
Stage IIA infiltrating ductal carcinoma,
left breast

TREATMENT
Chemotherapy (Adriamycin/Cytoxan
and Herceptin)
Bilateral mastectomy

FAMILY HISTORY
No

BREAST CANCER GENE
No

RESOURCES
Breast Cancer Stories
Lance Armstrong Foundation
WebMD
Pink Ribbon Girls
Young Survival Coalition

"I truly believe that Lexi's mother is my guardian angel; she probably saved my life. She had been unaware that young women could get breast cancer, and her initial diagnosis was late-stage."

WE HELPED TAKE CARE OF LEXI'S MOTHER BY taking her to doctor's appointments, chemo treatments, and finally hospice. It was so incredibly painful to watch someone so young go through so much. Lexi's mother was raised in the foster care system and had absolutely no support. Before we had met, she went to her mastectomy by herself.

She had experienced so much adversity throughout her life and she wanted to ensure that her baby grew up secure and loved.

After I myself was diagnosed, I was extremely scared...and angry. How could we just have adopted this beautiful baby and helped take care of her mother, watched her die from breast cancer at 24, and then I get diagnosed with breast cancer? Were my children going to grow up without a mother? Was Lexi going to lose two mothers to breast cancer? My oldest son remem-

bered all too well what it was like for Lexi's biological mother to get treatment and be sick. He was so scared that I would die, and frankly, so was I.

I truly believe that Lexi's mother is my guardian angel; she probably saved my life. She had been unaware that young women could get breast cancer, and her initial diagnosis was late stage. Afterwards she would tell everyone she knew to check their breasts. If I had never met her, I highly doubt I would have ever performed a self exam, and I would have been dead before my first mammogram.

After my diagnosis sunk in, I decided to fight like hell. I became a research junkie. I initially researched every type of surgery because that was the first step. I had to compartmentalize and completely focus on the type of surgery I would have, the best surgeons, then treatment options and

interviewing five oncologists with my husband, then healing, and now my new normalcy, which I am still trying to figure out!

I do remember the moment I got my "mojo" back, it was the Labor Day weekend after I had finished treatment and my family and I were at the lake. I woke up that morning and went to brush my teeth and realized that I had stumbles of hair on my head. I felt healthy and strong, and I was tubing with my husband and my kids. We were boating all day, and I was laughing and having fun; as I was waiting for them to get back on the tube, I realized "Holy Crap! I haven't thought about cancer all day — I am genuinely laughing and I didn't even have to fake it. I think I am going to be okay!" And that was the start of many baby steps towards healing.

Alexis Marie and Cara Lacey Salazar

ANDREA BASHOR
Registered Nurse, 30

"I would love to say that I don't sweat the small stuff, but I am still the same old me, just a little smarter. I really pay more attention to the suffering of others since I know how it feels to be down and how good it feels to come up."

DIAGNOSED
December 8, 2004, at age 27
Stage IIA infiltrating ductal carcinoma,
left breast

TREATMENT
Excisional biopsy
Lumpectomy
Sentinel node biopsy
Chemotherapy (Adriamycin/Cytoxan,
and Taxotere)
Radiation
Bilateral mastectomy

FAMILY HISTORY
Great aunt

BREAST CANCER GENE
No

RESOURCES
Breast Cancer Network of Strength
Breast Cancer Treatment and Information
Pink Ribbon Girls
Susan G. Komen for the Cure
Young Survival Coalition

KHADIJAH CARTER

Diversity & Programs Manager at Young Survival Coalition, 35

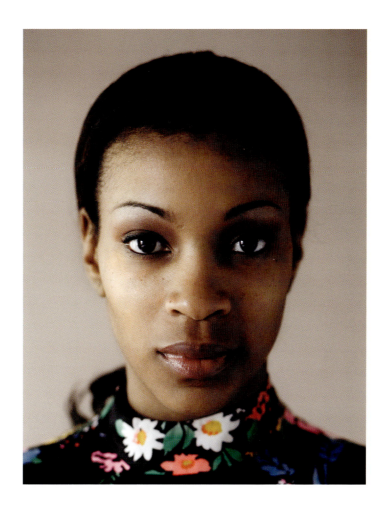

Young women can and do get breast cancer. While breast cancer in
young women accounts for a small percentage of all breast cancer cases, the
impact of this disease is widespread: There are more than 250,000
women living in the U.S. who were diagnosed with breast cancer at the age of
40 or under, and approximately 10,000 young women will be diagnosed
in the next year. *—from www.youngsurvival.org*

DIAGNOSED
April 2, 2003
Stage IIIA

TREATMENT
Mastectomy
Chemotherapy

FAMILY HISTORY
No

BREAST CANCER GENE
No

RESOURCES
Paint It Pink
Pink Roses Foundation Inc.
Sisters Network Inc: A National African-
American Breast Cancer Survivorship
Organization
This Day the Movement
Young Survival Coalition

KARYN LYONS

Artist, 46

"To face cancer and survive and not lose my mind, well, that is something I can draw upon whenever I am facing a challenge in my life or entering into an uncomfortable or intimidating situation. My strength through the process is something that can never be taken away from me."

DIAGNOSED :	TREATMENT	FAMILY HISTORY	RESOURCES
October 2006	Lumpectomy	No	Susan G. Komen for the Cure
Stage I	Chemotherapy (Adriamycin/Cytoxan, Taxol)		
	Radiation		

BREAST CANCER GENE
No

NATALIE GRUMET
Social Worker, 29

"I remember before cancer, going out of the house without makeup seemed like a big deal. That seems so petty in a funny way now."

WHEN I TURNED 27 YEARS OLD, I blew out my birthday candles and wished to get pregnant with my first baby. But three weeks later I was diagnosed with breast cancer. I had been having pain in my breast since May, and by July I found my lump.

I had been to the doctor twice, who told me I had probably pulled a muscle, or drank too much caffeine, and even "Maybe you've started carrying your purse on that side too much." Besides, I was told, breast cancer doesn't hurt. Two ultrasounds and two radiologist reports came back normal, showing "nothing was wrong."

I was getting the brush off, but I was in pain, had a lump, and knew something wasn't right. I insisted on an MRI. Follow-up messages I left for the doctor were ignored; then, two days after they had received the results, a staffer I had never even met called and told me that the MRI [results were] highly suggestive of carcinoma. I was in shock and I know this sounds weird, but relieved to finally know what was wrong with me.

Chemo was one of the hardest things for me to go through, and I was very fortunate to have an amazing support system. My parents really helped me get through it, and my husband has really been there for me as well — we always joke that those "through sickness and health" vows came a little earlier than planned.

I wish I could say I never felt scared, but I did, almost constantly in the beginning. Meeting other women fighting this horrible disease helped my resolve to fight, and I really gathered strength from them. I think the biggest thing that helps me fight is just feeling like my life is not finished. I want to grow old with my husband and have lots of babies. I want to make my parents proud. I want to live my life out. I don't ever want to give in to this ugly disease of cancer.

I read somewhere that cancer doesn't change you, it just amplifies the person you have always been. Another opinion is that cancer changes a person from the core. I go between the two thoughts depending on my mood. The optimist in me would like to believe that any change I have experienced

has been for the good. I am definitely more aware of all the positive things in my life and I make a conscious decision to focus on those things.

Going through chemo and breast cancer has made me gain more confidence in the person I am from the inside out. When you lose your hair, eyelashes, eyebrows and fingernails it can be hard to feel pretty much less feminine. I remember before cancer, going out of the house without makeup seemed like a big deal. That seems so petty in a funny way now. But meeting so many strong and amazing women who battle this disease helps to give a new definition of the word "femininity" — it has become more about the strong fighting spirit that all women have inside them.

I am excited to move forward in my life and pray that this is something I will never have to go through again. The last nine months have been painful, yet freeing. I have faced death and come out ahead. At this moment I can say that I am cancer free. I pray to stay that way.

DIAGNOSED
August 31, 2007
Stage II invasive ductal carcinoma, left breast
ER/PR negative, HER2neu

TREATMENT
Neo-adjuvant chemotherapy
Carboplatin, Taxotere
Bilateral mastectomy

FAMILY HISTORY
Grandmother is a 7 year breast cancer survivor

BREAST CANCER GENE
No

RESOURCES
Breastcancer.org
BreastCancerStories.org
Links for Life: Helping Women with Breast Cancer in Kern County
Young Survival Coalition

ELISSA VICTORIA CARIOTI
Director of Leasing, 30

"'I rule cancer, cancer does not rule me,' I thought...then it recurred. I am not so sure anymore. However, I still feel there must be a higher reason that I would be forced to face this for my entire life. I don't know if I will win or lose, but I do know there is always a purpose."

DIAGNOSED
January 2005, at 25
Stage 0 ductal carcinoma in situ
July 2007, at age 28
Stage I ductal carcinoma in situ with small invasive area

TREATMENT
Lumpectomy
Radiation
Bilateral mastectomy

FAMILY HISTORY
Great-grandmother, grandmother, and mother

BREAST CANCER GENE
Unknown

RESOURCES
Cancer Care NYC Post-Treatment
Young Survival Coalition

Fighting the Fight

DIKLA BENZEEVI

Breast Cancer Patient Advocate and Public Speaker, 39

"Going through cancer treatment once and hoping it is
cured is challenging enough. Going through cancer several
times, and then continually being in treatment and
battling the disease is altogether a new level of coping and learning
to live with mortality each and every day. I did not think I
would escape breast cancer, since my mom and two
aunts had it (in their 40s to 60s). I thought the minute I turned 40,
I would be the most diligent person to take care
of their breast health. But breast cancer beat me to the
punch by eight years. I never imagined in my wildest dreams
that I would be diagnosed at the age of 32."

DIAGNOSED
August 2002
Stage III high grade, infiltrating ductal
carcinoma, no nodes involved
December 2005
Metastasis to the spine
July 2007
Metastasis to the lung
ER, PR, HER2 positive

TREATMENT
INITIAL DIAGNOSIS
Chemotherapy (Carboplatin, Taxotere)
Herceptin
Zoladex
Lumpectomy and lymph node dissection
(39 lymph nodes removed)
Re-excision surgery
Radiation
Tamoxifen

SECOND DIAGNOSIS
Faslodex
Zometa
Herceptin
Vertebra radiation
Vertebrectomy/vertebra fusion surgery
Physical therapy

THIRD DIAGNOSIS
Faslodex
Zometa
Herceptin
Zoladex
Bronchoscopy, VATS wedge resection

DEATH RATES FROM BREAST CANCER HAVE BEEN DECLINING SINCE ABOUT 1990, WITH
LARGER DECREASES IN WOMEN YOUNGER THAN 50. THESE DECREASES
ARE BELIEVED TO BE THE RESULT OF EARLIER DETECTION THROUGH SCREENING AND
INCREASED AWARENESS, AS WELL AS IMPROVED TREATMENT.

DIKLA BENZEEVI

Breast Cancer Patient Advocate and Public Speaker, 39

THE NEXT SEVERAL WEEKS FELT LIKE A PAN-ICKED RACE to figure out what to do about the cancer growing in my body. I was still working and always rushing, barely sleeping. Work, appointments, oncologists, surgeons, counselors, fertility experts, PET scans, CT scans, MRI scans, blood work… it was endless.

I knew I wouldn't die from the breast cancer. Even though my mom and her sister both died of breast cancer, I somehow felt secure that modern day cancer therapies would protect me and help me. My main concerns were if I could bear the treatments and surgeries, the pain, the potential disability, and work issues.

After my initial diagnosis in 2002, I finished treatment in late 2003. I had gained 35 pounds and was not in shape. I was told to take time off but I worked nearly full time through my chemotherapy, targeted therapies, surgeries and hormonal therapies. Ten months after treatment I was completely exhausted — my friends said I looked like "death warmed over." I continued to work, but finally had to take a medical leave in May of 2004. My body was completely worn out.

The first month I went to pilates for an hour — and spent the rest of the day in bed, exhausted. It took a good six months of dedicated self-care, healthy eating and exercise habits, and mandatory daily rest periods to feel normal, lucid and rested.

Just as I was feeling ready to return to work, I was diagnosed with breast cancer metastasis to the spine.

The spine metastases was a whole new level of chaos and panic for me. The spine tumor grew so quick that by the time I started a new therapy to deal with it, it had grown 50%, fractured my vertebra and posed a serious risk to my spinal cord that could possibly paralyze me. I had horrendous pain in my back from the cancer. I had radiation therapy to help with the back pain. My doctors immediately placed me in a back brace to reduce the risk of spinal cord injury, and recommended I undergo a serious spine fusion surgery to correct the fracture. I was petrified with this diagnosis, because my worst fears seemed more real now than they did with the initial breast cancer: The fear of disability and the fear of pain.

I had the surgery in March of 2005. The recovery process was long, intense, and painful. I was home in bed on pain drugs for a good month. I was in a back brace for a full five months and needed an additional six months of physical therapy to strengthen the now weakened back muscles. It was a slow and exhausting process, but extremely successful. After a year of proper self care, good food, exercise, and a balanced pace of rest and advocacy work, I felt strong, energetic and in the best shape of my life.

My third diagnosis, of breast cancer metastasis to my lungs in the summer of 2007, was also a shock. With every new diagnosis, I worry if treatment will work to repress or eliminate the cancer. I also have tremendous hope and faith that it will. I am now on a modified therapy with its new string of side effects I am learning to cope with and overcome. I recently had lung surgery to remove two tumors in my left lung. All stressful events. However, having my family and my network of friends, colleagues, peers and supporters all encourage and inspire me to keep plugging along, to make each day as meaningful as possible, and to live each day fully.

My first diagnosis taught me to share and to open up to others, to help others in need and to build a community of support for all affected by breast cancer — to be a breast cancer advocate and speaker. My second diagnosis taught me to take care of my body. My third diagnosis is teaching me to accept, to love, to take care and to listen to my entire being and its needs and wants. Not to suppress or diminish or belittle or criticize, but to embrace, nourish and encourage all parts — the imperfect as well as the skilled, not just in me but in all those around me. It is a work in progress, my new challenge for myself.

As I was sitting in my car today, I thought of the yoga pose called "Tree Pose" where you stand straight and raise your arms up. I thought it was a good metaphor of the way I endeavor to pursue my life. The pose states to stand with feet together, standing strong, as though your feet had roots underground and were holding your legs strong, steady, and sturdy. Nothing can move them. The pose then states to hold your body and head up straight, as though a thread or balloon from the top of your head is pulling you skyward and your body and arms are light as air.

I like the pose because it describes a balanced lifestyle. A person is rooted and grounded in their core beliefs and place in life. The person is also looking forward and up at the endless light and creative possibilities, moving flexibly with the wind or outside circumstances, but not floating away (losing focus) or sinking into the ground. I like the image. Grounded, yet looking forward and up.

At this time in my life, I look forward to the future. I feel I have one.

FAMILY HISTORY
Mother diagnosed at age 54, died at 56
Maternal aunt died at age 42
Paternal aunt diagnosed at age 64, she survived
Father passed away of colon cancer

BREAST CANCER GENE
No

RESOURCES
BCMets.org
Breastcancer.org
Her2 Support Group
Simms/Mann UCLA Center for Integrative Oncology
Susan G. Komen for the Cure
We Spark Cancer Support Center
Young Survival Coalition

YASUKO KAWAMURA
Fashion Boutique Manager, 36

"I don't define myself so much as a cancer survivor; it's more like I had a great, life-changing experience that's made me feel even more *connected* to humankind. "

I WAS DIAGNOSED LAST DECEMBER when I went to the Breast Examination Center of Harlem (BECH), after I discovered a suspicious lump during a self-examination at home. After a full battery of examinations, tests, biopsies, and a mammogram, I was diagnosed with stage II breast cancer and was immediately referred to Ralph Lauren Center for Cancer Care and Prevention (RLC) for evaluation and treatment.

I was totally shocked. I have been a competitive athlete all of my life, and it was so unreal to me that it could be even remotely possible, as I was otherwise so incredibly healthy and strong. Why? Why? Why? I was so desperate, especially when I thought of my parents in Japan — I felt so sorry for them, more than myself.

I soon realized that I had to deal with another unexpected reality — a cancer treatment regimen can run into hundreds of thousands, even millions of dollars, and I didn't have any medical insurance, nor any savings to pay for any kind of cancer care. Ironically, that caused even more concern for me than the cancer itself. It was an overwhelming problem.

I was extremely fortunate in that RLC has something called the Patient Navigation Program (PNP), which features specially-trained "patient navigators" who help guide patients through the complexities of the healthcare system, financial assistance, and other obstacles. Because of my patient navigator's compassionate concern and dedication to easing my worries and fears, I was able to secure emergency Medicaid, and I felt like I finally had a fighting chance.

Medicaid has since fully covered the costs of my cancer treatment, and needless to say, it was like a miracle. So I'd like to relate how important knowledge and access is to the actual physical and spiritual fight, as well the clinical therapies and healing processes against cancer.

As for getting through the physical part of it, I got a lot of courage and inspiration from Lance Armstrong's story — his way of fighting cancer was very relevant for me. Growing up I played baseball, softball, and volleyball, and now I play roller hockey with a bunch of guys. During my college volleyball career, our daily practices and training were extremely tough — I was

often pushed until I thought I couldn't stand it anymore, both physically and mentally, but I never gave up. Eventually this toughness led us to win the National Championships twice. I found myself applying that experience in my fight against cancer.

Since undergoing surgery and treatment I've been feeling absolutely normal, I don't think about my cancer situation so much. I haven't done my reconstruction yet because of my Medicaid situation, and I don't know if I could have it anytime soon, or ever. Basically I'm living with only one boob, but I still feel okay. I still feel I'm attractive.

I don't define myself so much as a cancer survivor; it's more like I had a great, life-changing experience that's made me feel even more connected to humankind. I feel really good whenever I can help out another patient, especially in giving them an optimistic sense of hope and empowerment and encouraging them to take informational control of their treatment. That old saying that "knowledge is power" applies completely when dealing with everything you have to understand, endure, overcome, and accept with cancer.

DIAGNOSED
January 2007
Stage II invasive ductal carcinoma

TREATMENT
Chemotherapy (Adriamycin/Cyclophosph-amide, Taxotere/Herceptin)
Mastectomy
Surgery to remove left axillaries (12 nodes all negative)

FAMILY HISTORY
Maternal aunt diagnosed in late 40s

BREAST CANCER GENE
Unknown

RESOURCES
Breast Cancer Treatment Information and Pictures
Breast Examination Center of Harlem
Ralph Lauren Center for Cancer Care and Prevention
Young Survival Coalition

PHOTOGRAPHY CREDITS

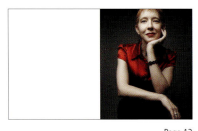

Page 13
Nancy Sue Bayruns-Sklencar by Mike McGregor

Page 14 / 15
Greta M. Cerpa by Ryuhei Shindo

Page 16
Lea Siegel by Elizabeth Young

Page 19
Ellen Skalski by Mike McGregor

Page 20
Jacqueline Lou Skaggs by Ryuhei Shindo

Page 23
Jacqueline Lou Skaggs by Ryuhei Shindo

Page 24 / 25
Pamela K. Embury by Mike McGregor

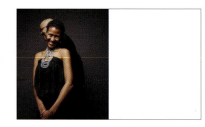

Page 26
Arnaldo & Vanessa Silva by Mike McGregor

Page 28
Arnaldo & Vanessa Silva by Mike McGregor

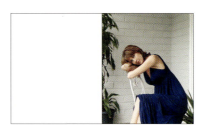

Page 31
Stefanie LaRue by Monica May

Page 32 / 33
Lisa Suit by Ryuhei Shindo

Page 35
Diana Featherstone by Mike McGregor

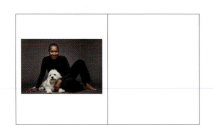

Page 36
Cabrini Schneider by Mike McGregor

Page 38
Cabrini Schneider by Mike McGregor

Page 41
Amanda Nixon by Monica May

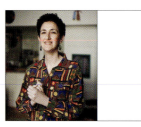

Page 42
Michele Forsten by Ryuhei Shindo

PHOTOGRAPHY CREDITS

Page 47
Lois Fisher by Mike McGregor

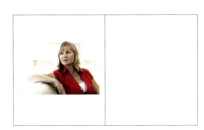

Page 48
Adrianna Showalter by Monica May

Page 51
Sheila M. Slaughter by Ryuhei Shindo

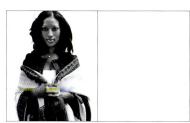

Page 52
Maimah Karmo by Mike McGregor

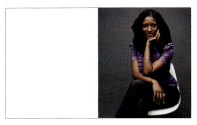

Page 55
Maimah Karmo by Mike McGregor

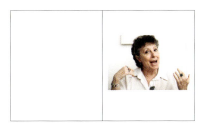

Page 57
Susan Schwalb by Ryuhei Shindo

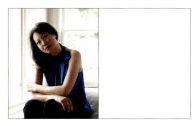

Page 58
Delia Gay De Perio by Monica May

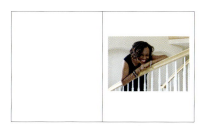

Page 62
Patricia Jefferies-McDowell by Monica May

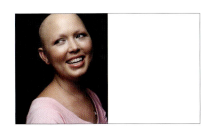

Page 64
Lisabet Buesing by Mike McGregor

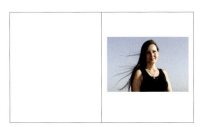

Page 67
Courtney Lercara Zinszer by Monica May

Page 68
Darlene Fountaine by Monica May

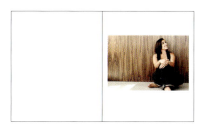

Page 71
Sarina Salieri-Holborn by Monica May

Page 72
Meredith Norton by Mike McGregor

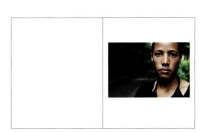

Page 75
Meredith Norton by Mike McGregor

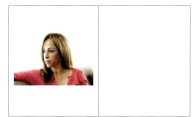

Page 76
Janine McMillon by Monica May

Page 78 / 79
Tracie Metzger by Mike McGregor

PHOTOGRAPHY CREDITS

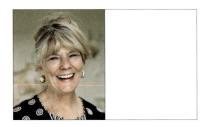

Page 80
Barbara Ann Boyer by Elizabeth Young

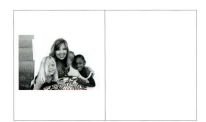

Page 82
Heather Salazar and daughters Cara Lacey and Alexis Marie by Mike McGregor

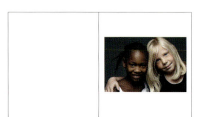

Page 85
Alexis Marie and Cara Lacey Salazar by Mike McGregor

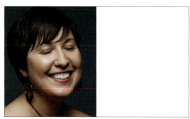

Page 86
Andrea Bashor by Mike McGregor

Page 88 / 89
Khadijah Carter by Ryuhei Shindo

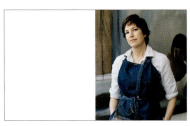

Page 91
Karyn Lyons by Elizabeth Young

Page 92
Natalie Grumet by Monica May

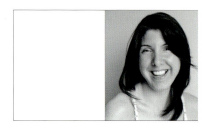

Page 95
Elissa Victoria Carioti by Elizabeth Young

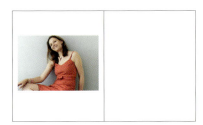

Page 96
Dikla Benzeevi by Monica May

Page 100
Yasuko Kawamura by Elizabeth Young

Front and Back Cover
Lisabet Buesing by Mike McGregor

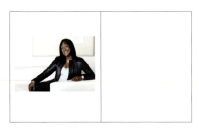

Page 6
Carolyn Jones by John Russo

AKNOWLEDGEMENTS

FOR BEING INSTRUMENTAL IN HELPING US FIND THE AMAZING
STORIES IN THIS BOOK, SPECIAL THANKS TO:

Young Survival Coalition
Khadijah Carter
Breast Cancer Network of Strength
Heather Salazaar

THE BEST CREATIVE TEAM

Johnny Quach
Janelle Kilpatrick
Alex Cifuentes
Marquice Johnson

THE MOST AMAZING MANAGEMENT TEAM

Yvette Campbell
Alycia Ballou
Myra McMillian
Rhonda Sawyer
Rhonda Kilpatrick
Nancy Gonzales
Gonzalo Posada

EDITOR AND CONTENT COACH

Diane L. Smith

And a very special thanks to Cameron Jones for being the best daughter ever and
for really understanding the importance of this book and for taking such an amazing interest
in breast cancer programs at such a young age.

JEAN MARIE JAMES

"Love Took Wings Bound Towards Heaven"

Jean Marie Ramsey is the inspiration of the PRVCY Premium and PrivacyWear
denim brands. Our hope is that everyone that reads the book finds
a piece of inspiration and encouragement. To learn more about early detection,
self exams and the Jean Marie Ramsey Free Mammogram Program
sponsored by PrivacyWear, please visit our website at PrivacyWear.com.

IN LOVING MEMORY OF

Jean Marie James
AND
Lisabet Buesing

Inspired Lives: Portraits Of Breast Cancer Survivors
© PrivacyWear & PRVCY Premium

Photographs © Monica May, Mike McGregor,
John Russo, Ryuhei Shindo, Elizabeth Young

Text © PrivacyWear & PRVCY Premium

Published by PrivacyWear & PRVCY Premium
Diamond Decisions, Inc
1191 Magnolia Avenue Suite D418
Corona, CA 92879

ISBN: 978-0-692-00352-7

Inspired Lives: Portraits of Breast Cancer Survivors
Concepted, Produced, and Designed by
emeht, PrivacyWear and PRVCY Premium Denim

Photographs by Monica May,
Mike McGregor, John Russo, Ryuhei Shindo,
Elizabeth Young

Retouching by House

Printed and Bound in China